OMAR KHOLEIF

Sonia Balassanian

T0266627

Series Editor: Dr. Omar Kholeif
Commissioning Editors: Caroline Schneider and Dr. Omar Kholeif
Editor, Volume 1: Rebecca Morrill

Editorial Advisory Committee:
Skye Arundhati-Thomas
Zoe Butt
Carla Chammas
Alison Hearst
Professor Sarah Perks

Design: Simon Josebury, **SecMoCo,** London
Printed and bound at Aldgate Press, London

Series: *Imagine Otherwise*
Volume 1: Sonia Balassanian

An artPost21 Production **art■ost21**

OMAR KHOLEIF

Sonia Balassanian

imagine*otherwise*

Sternberg Press

imagineotherwise

Imagine Otherwise is an anthology of books on queer, non-binary, or female-identifying artists who have produced a substantial body of work but may have no publication concerning their art or life in print at the time of commissioning. The series—a living archive and a modular score— comprises books that serve as field guides into artistic lives that remain unexplored or inaccessible. The overall proposition, to "imagine" a world "otherwise," stems from the desire to find a different way of looking, writing, and reading about art. To consciously create a form of publishing that allows art to be examined unreservedly, unburdened of the limits imposed by any perceived "dominant hand" of hegemony. Imagine if every book on art was authored or narrated via the distinct contours of the artist's work and/or biography—the writer and artist guiding the reader through a personal lens, in their distinct voice, rarely conforming to a singular style. Each book in the series is conceived as an exploratory document and collaborative composition. Together, author and artist, dead or alive, propose acts of worldbuilding—fulfilling a dream to explode the sanctioned modes through which art is experienced in the collective imagination.

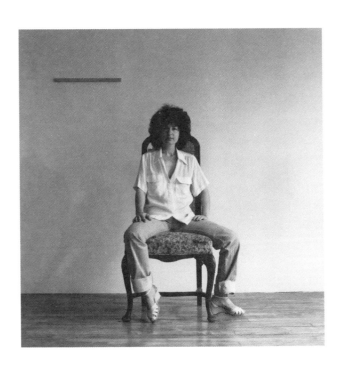

Portrait of Sonia Balassanian in her studio, 1980, New York. Photograph: Toba Tucker

Contents

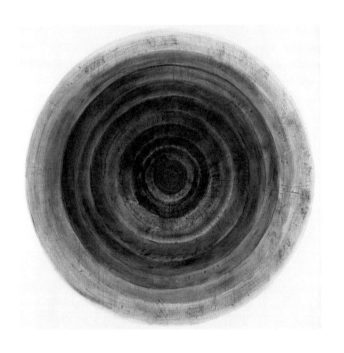

Untitled, 2010, acrylic on canvas, 178 × 178 cm

Hello, Sonia
Hello, World!

Let me begin by noting how surprised, dazzled, and puzzled
I was to have recently happened upon the full extent of Sonia
Balassanian's life and art at the outset of this project—exposed
to her art only in the later stage of her life. Could it be that
one of the most significant and original artistic voices of the
oft-mythologized US art scene of the 1970s and '80s—the
vogueish avant-garde of New York's Tribeca, Soho, and East
Village loft scenes—obscured Sonia from view? Could she have
fostered an alternative dialogue on abstract and activist art in
the United States, had her work been offered the public forums
afforded to her peers? Perhaps such searching questions are
akin to speculative fiction. Many of the individuals of the time
who are now the subject of folkloric retelling underwent similar
experiences. Artists such as Judith Barry, Marilyn Minter, and
Laurie Simmons, for instance, were fêted early in their careers, but
did not return into view until subsequent generations of younger
writers, curators and historians discovered, and sought out, their
work. Similarly, although now the subject of much acclaim and
fandom, David Wojnarowicz (1954–92), lived much of his early
adulthood in squalor, then gained recognition for his art in the late
1970s and '80s, only to fall into illness, and then relative obscurity,
for almost two decades after his death until the 2010s. Likewise,
other New Yorkers, including the pioneer of photography, Jimmy
DeSana (1949–90), and postmodernist author, Kathy Acker
(1947–97), went unrecognized from mainstream culture until after
their death. Even the "punk poetess," author, artist, and musician
Patti Smith, once informed me[1] that "recognition"[2] only emerged

during her initial retirement and financial reward only arrived after the success of her memoir, *Just Kids* (2010). The collective imagination around Punk and New Wave in New York City in the late '70s, which has been reconstituted by authors including Rachel Kushner in *The Flamethrowers* (2013), and Garth Risk Hallberg in *City on Fire* (2015), exhibits a yearning nostalgia for an era when poverty and anarchy led to tremendous feats of creativity.[3] But who was left out of this story? Who was beyond the underground? This, the first volume in the series, *Imagine Otherwise*, begins an act of reconstitution.

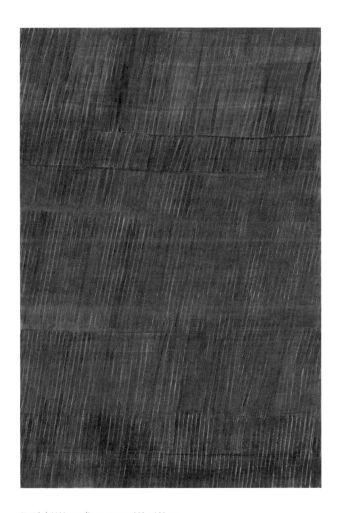

Untitled, 2020, acrylic on canvas, 183 × 122 cm

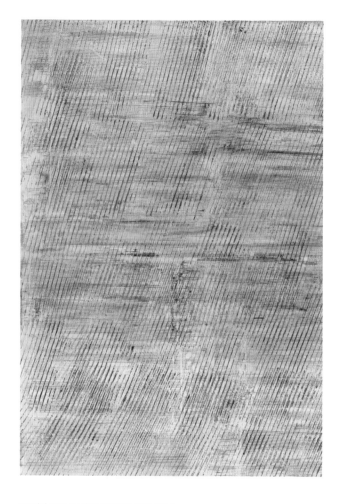

Untitled, 2020, acrylic on canvas, 183 × 152 cm

A Preamble

I am digging a pit
where I and a beast
will be buried.

 Sonia Balassanian (Published 1991)

In attempting to sketch the contours of a life, namely that of the polymath—poet, artist, curator, theater-maker, and educator—Sonia Balassanian, I keep returning to an artwork by another multi-hyphenate, two generations younger, Sophia Al-Maria. In 2019 I was confounded and enraptured by her film, whose title and nature proffer a pertinent beginning: "Beast Type Song."[4] Al-Maria described the 38-minute video as "dense, layered, a text full of other texts."[5] Highlighting the propensity for translations and mistranslations within it, I submitted myself to the drifting consciousness of "storytelling" as articulated by Walter Benjamin (1894–1940). Arguing in favor of oral histories, for the fabulation of the narrator—a romantic style of magical realism—Benjamin argued that the distinguishing feature of the storyteller, versus that of the novelist, lay in the expression of experience. "The storyteller takes what [they tell] from experience,"[6] and may—indeed often chooses to—represent their tale in such a manner as to make it directly relevant to the experience of the listener. The desire for human connection is implicit.[7]

My quest to "know" the details of the life of Sonia Balassanian, someone who was once described as one of her generation's "most significant political artists,"[8] and by proxy, to delve deeper into

the setting—the routes that led to her development as an artist—demanded an act of careful listening, a space of hushed breath. My interrogation was initially kept minimal, to allow for the impulses and intuition of this book's subject to take on a choreographic form that befitted her life's work. This is stated to highlight that this narrator may in places be unreliable, but that within this sphere, space is deliberately left for the reader to fill in the gaps of history with their own worldview. We are just scratching the surface here and that is how this story is intended to be told.[9]

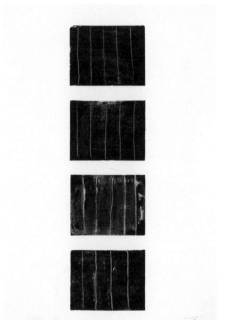

Untitled No. 5, 1980
Mixed media on paper
100 × 70.5 cm

Opposite:
Untitled, 2020
Acrylic on canvas
183 × 152 cm

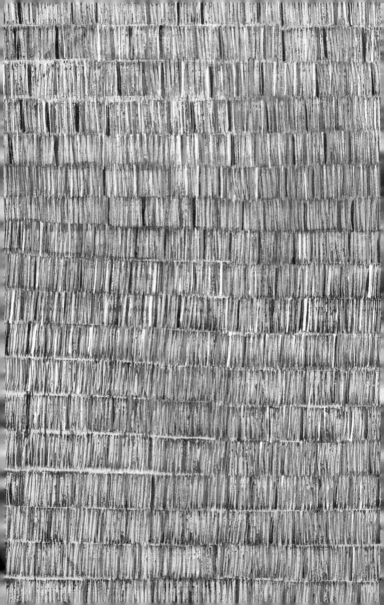

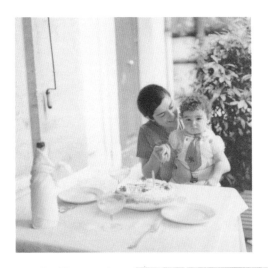

Sonia and her son Arn in
their home Tehran, 1969

Right: Balassanian Family.
Sonia is third from right in
the center, next to tall man
(Edward Balassanian).
Photographer unknown.

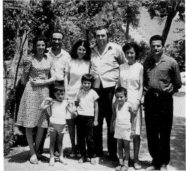

A Biography of a Sort

The Seconds expire.
Time doesn't stop to rest.
 It runs breathlessly ...
 Sonia Balassanian (Published 1991)

It is late evening in London, and I am attempting to speak to Sonia in New York. She is aged eighty at this point. Her son, Arné, downloads WhatsApp onto her mobile phone and within the space of minutes, I have three missed calls from her. I dial back hurriedly; she is a little out of breath. Sonia informs me that she has just returned from fulfilling an important aspect of her daily routine—walking from her loft, which also houses her studio, in Tribeca, which she has occupied since the 1970s, down to the banks of the Hudson River. As she describes the rippling effects of the water, I begin to mentally conjure her abstract paintings, which often resemble language, swelling and subsiding into the skin of the canvas. The history of the Hudson River evades our conversation, but the context of the waterway as a political boundary between the states of New Jersey and New York does not escape me. Nor does its colonial history as a location for Dutch settlers, and its presence as a site of contamination—victim to the likes of General Electric (GE)—instigating long-term ecological concern. Instead, Sonia gleans a metaphor of the shapely water as suggestive of alphabetical forms—the intimation of language is prescient for someone who has lived most of her professional life in a country—the United States—where communication is performed through speech acts that diverge from her mother tongue: Armenian.

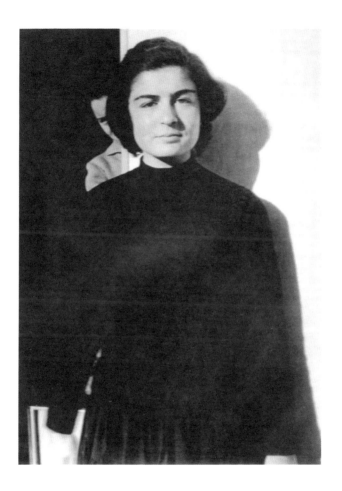

Portrait of the artist in Arak, near Isfahan, Iran, mid-1950s. Photographer unknown.
Left: *Untitled*, 2020, acrylic on canvas, 183 × 122 cm

This is only the second time we have spoken. The first was on Skype with "Matinfar," as she refers to researcher, Salman Matinfar, one half of the co-founding duo of Ab-Anbar gallery. It was created with architectural historian and lecturer, Azadeh Zaferani, to create "bridges" to under-served artists. "I didn't want to Google you," Sonia professes. I sit taciturnly. "Hello? Can you hear me?" She summons me into the conversation. I am asked for a personal biography as opposed to narrating my credentials.

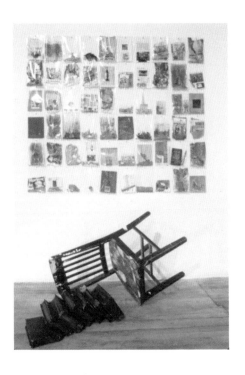

War Series, 1982
Mixed media
installation

Installation view:
Visual Politics,
an exhibition
at Alternative
Museum,
New York, 1982

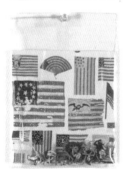

Persistent and inquisitive, the artist is curious about the movements in my life—querying various forms of identification, so that, one assumes, the storyteller can determine how best to construct her own tale. "I was raised in a very strict household: eight girls and two boys," she begins, as the pendulum swings back. She was born Sonia Amirian in Arak, Iran, in 1942, to a father of Armenian descent. Her ancestors had moved from what would become the Armenian region near Isfahan in the early seventeenth century, during the Safavid dynasty, forming the city of Jolfa. Many Armenian immigrants, including Sonia's family, were known for their specialist knowledge of silk and were invited to Iran to aid in silk production for export. The Armenian community in Iran was to swell in a second wave of immigration due to the Armenian genocide and the ensuing deportations of the Ottoman Empire from 1915 to 1923. As was not uncommon, Sonia's life would career into the diaspora over time.

Sonia's father insisted upon a form of studiousness that she felt oppressive, so exit strategies brewed in her mind. She gasps in delight as she recollects laying in a small nook on the balcony of her family's home at night. Then a teenager, she sought to invent her own world, one which she unfolded in poetry—her first point of fixation. Her words, authored in Armenian (the language spoken at home), began with reflections on nature, before turning inwards: "To wring, to tear apart old memories/ To leave home consciously/ To walk until dawn/ And with all one's being." Her poems, all of which are untitled, and authored in interleaving verse, mostly remain untranslated. All are undated, so their origin can only be determined, I am informed by her husband, via two collected anthologies that were published in 1982 and 1991, respectively. Sonia, who would become a member of "Nor EJ" (New Page)

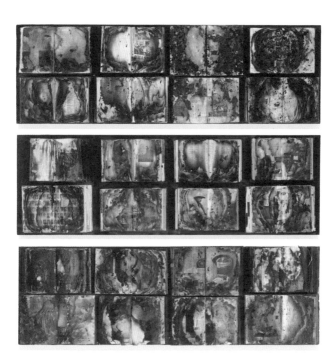

Cauterized Literature, 1987, mixed media installation, 66 × 203 × 20 cm (each panel)

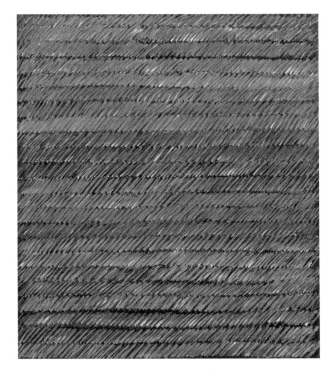

Untitled, 1970, acrylic on canvas, 133 × 122 cm

group—a notable Armenian poetry group in Tehran—recounted the teasing from her peer group of interlocutors who implied that someone else had authored her lyrical stanzas. If anything, this prodding served as helpful encouragement, propelling her to experiments with words from outside of the formal languages, such as the vernacular of rural Armenian villages, intersplicing the myriad possibilities offered by the space of the poem and the field of poetics.

At twenty-three years of age, Sonia married Edward Balassanian, who suggested the couple move to Britain for a year to hone their English-language skills before they relocated to the United States, where Sonia had been accepted into the joint art program of the Pennsylvania Academy of Arts and University of Pennsylvania, Philadelphia. It was a historic school, known for alumni including Mary Cassatt (1844–1926), Thomas Eakins (1844–1916), and Henry Ossawa Tanner (1859–1937), and more recently celebrated for graduates such as Njideka Akunyili Crosby, Barkley L. Hendricks (1945–2017), and David Lynch. Sonia graduated in 1970, but it was the following year, when she began the Whitney Independent Study Program in New York, that she become invigorated with an unbridled fervor for testing the formal limits in and around artmaking. Significant artistic figures Frank Stella, Lucas Samaras, and Robert Rauschenberg (1925–2008) were mentors on the course at the time, but the thrill for Sonia had more to do with her encounters than with any formal teaching.

The organizers of the program convened impromptu gatherings and, on several occasions, sought to sully the disciplinary boundaries of art. Sonia recalls that it was upon seeing ballet dancers perform for them that she reconciled herself with the

possibility of using her body as a border, a site of contingency, and a field of vision, in her own artmaking. The New York art scene "just unfolded before my eyes … and that gave me an entirely different way of experiencing and seeing myself."[10] The words fell out of her mouth with an optimistic glee that both enlivened and perplexed me. Although she has been making art for more than five decades, with budding critical acclaim in the late 1970s and early '80s, followed by a swell of activity in the early 1990s, Balassanian has nary exhibited in the city in which she continues to live, despite newfound international recognition in the mid-2000s. Her buoyancy is reminiscent of the joys expressed by Martinican philosopher and poet, Édouard Glissant (1928–2011), who once stated that in a difficult situation, one should not retreat to the realm of the perceived subaltern, but instead, "realize [one's] dreams, in order to deserve your reality."[11]

And that she did, in time, by co-founding, with Edward Balassanian, the longest continuing art space in Armenia—the Armenian Center for Experimental Contemporary Art—in Yerevan, the capital of Armenia in 1992, one year after the Armenian independence referendum that marked its secession from the Soviet Union. The art center would become a nourishing site of curatorial experimentation and, notably, it developed Balassanian's practice as an arts educator.[12] With the assistance of family, colleagues, and artists of the Armenian diaspora, she has helped seed programs that have supported emerging artists from the Southern Caucuses. From here on, her life would become split between Yerevan and New York.

While Sonia's journeys between the United States and Iran were initially fueled by the pursuit of education, they would later

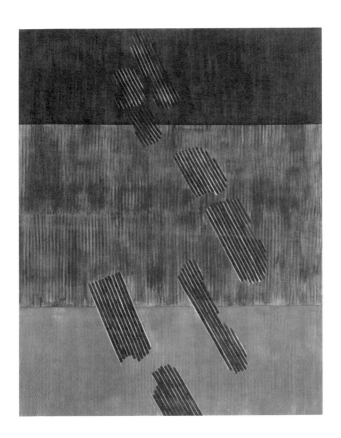

Untitled, 2020, acrylic on canvas, 193 × 152.5 cm

become a necessity for survival and shelter. The Iranian Revolution of 1978–79, which overthrew the country's ruling dynasty and created an Islamic republic under the leadership of Ayatollah Ruhollah Khomeini, notoriously created multiple seats of exile. For Sonia this became a second hostile takeover on her home. The Armenian genocide that began in 1915 is, to this day, not acknowledged by the political actors who culled and destroyed Armenian lives and annexed the nation's lands. The governing forces of the Ottoman Empire—the historical culprits of the genocide—although now dissolved from their original form, nevertheless present an evocative lens through which to perceive of Sonia's life. One could argue that, in essence, she was in constant search of a dominion of her own life, which could not, in the end, be contained by form, but rather, moved from lyric to canvas, creating cellular topographies that stretched and shifted with the political tides of the Iranian Revolution.

Balassanian's pursuits began in the realm of the formal—exploring the transcendental prospect of a singular dimension as a painter—cultivating an abstract frame of reference that was entirely her own. The artist confesses that she deeply disliked overly representational art, fearing that didacticism pollutes art's potential to connect different disciplinary fields and ideas, or the possibility to query an ideology. That said, the revolution in Iran marked a shift in her practice. Sonia began identifying as a political activist and deconstructing political violence in her artwork. A shift to self-portraiture, collage, photography, and video ensued; then onto

Sonia Balassanian working in her home studio, 2019, Tribeca, New York. Photograph: Arn Balassanian.

28

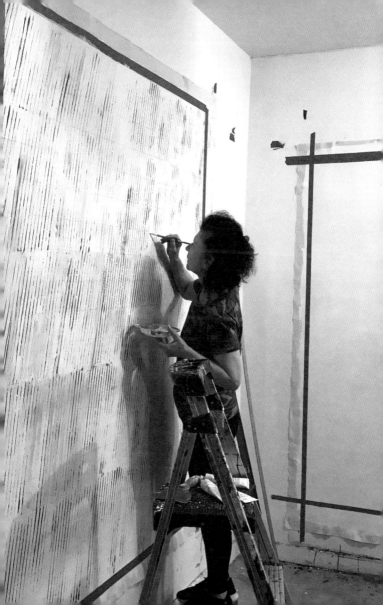

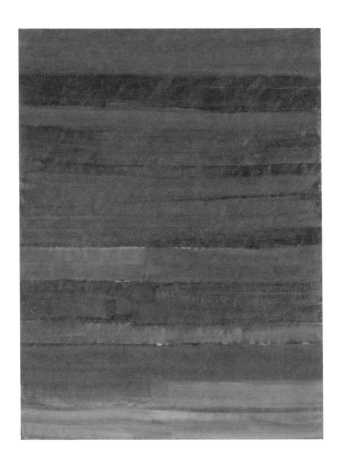

Untitled, 2020, acrylic on canvas, 101 × 76 cm
Following pages: *Untitled*, 1978, acrylic and mixed media on canvas, 129.5 × 199 cm

installation, sound, and live performance, in all its possible configurations, transforming her into a polymath.

This concept of the polymath—a sage, a human with expansive knowledge or potential for doing multiple things—has made a significant return into view in our free-wheeling present. Credit for this is often given to the networked culture of the internet age for enabling an auto-didactic, do-it-yourself, community-orientated culture that is formed organically online, fashioning innumerable notions of visual culture. Contrarily, one of the most arresting features of some of the most significant polymaths of the present—from the late designer Virgil Abloh (1980–2021), musician Kanye West, and Tesla CEO Elon Musk, or media moguls such as reality-star Kim Kardashian, actress and goop founder Gwyneth Paltrow, and actress and broadcaster Tina Fey—is that their status is determined by capitalist success. Historically, the polymath, which pulls together the Greek "poly" ("of many") and "mathē" ("knowledge") to mean "one who has learned much," is expressed in Latin as *homo universalis*—the "universal human."

It would perhaps be more appropriate to situate Sonia Balassanian's identity as polymath as both an outcome of necessity, and of her unrelenting curiosity. Her stream of influences can be located within the edges of historical figures. One such example is Omar Khayyam (1048–1131), an astronomer, philosopher, and mathematician who reformed the solar calendar and is best known for his Persian poetry, in the *Rubaiyat*. Another is the poet and scientist, Hasan Ibn Al Haytham, popularly referred to as Alhazen (c. 965–1040), whose momentous *Kitāb al-Manāir* (*Book of Optics*) laid the foundations for the pinhole camera which, in turn, prompted the invention of the modern camera. Likewise,

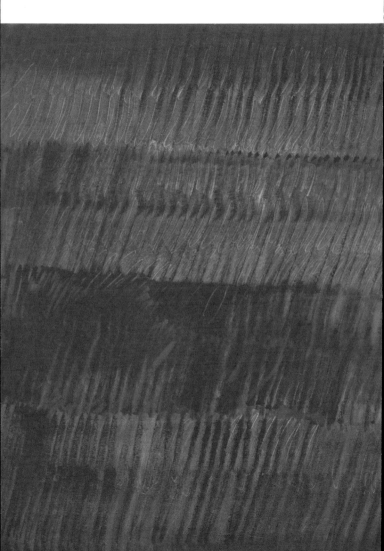

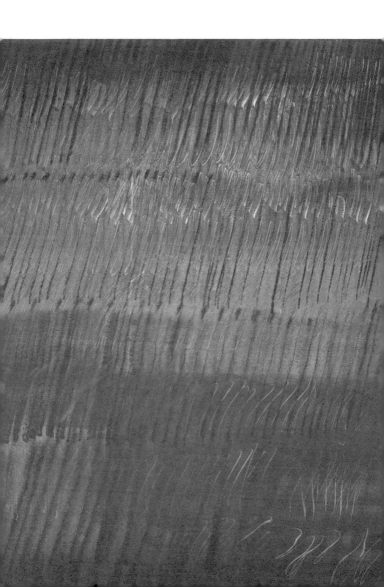

Armenian Iranian, and American polymath, Marcos Grigorian
also known as Marco Grigorian (1925–2007), who equally adopted
multiple personae. After studying art, he continued his pursuits as
an artist, but also founded a contemporary art gallery, organized
major not-for-profit exhibitions, was a triathlete, as well as an actor
in Iranian films in the 1960s and 70s, going by the screen name of
Marc Gregory.[14] The entanglements that these individuals possessed
and their fashioning of multiple worlds, parallels with Sonia
Balassanian's life and work. She chose not to dwell in a continuum.
Despite her work being presented in the 1990s as a form of
ethno-exoticism in the United States, she resisted this context,
teaching herself how to use a Sony Video 8 camcorder to produce
strident films that metaphorized the human body into contorted
architectures. Meanwhile, she continued to author poetry, to
remain politically active—focusing on the issue of women's
emancipation—alongside organizing exhibitions and residencies,
and teaching. Her biography offers a passage through which to
examine and encounter the sensitivities that emerge in and out of
"the weight of the world."[15]

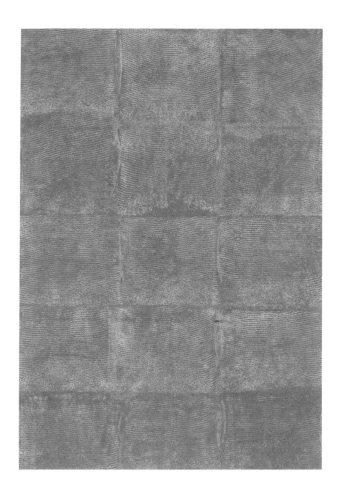

Untitled, 2020, acrylic on canvas, 183 × 122 cm

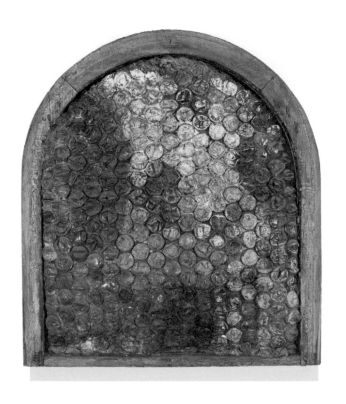

No. 6, from the *Arch* series, 1982, mixed media installation, 62 × 65 × 10 cm
Following pages: *Untitled*, 1978, mixed media on canvas, 183 × 264 cm

A Poem Begins a Line, Emerges a Painting, or a Life's Work

To mix the smoke of the roof
with the blue of the sky,
... Watch the herd graze
... open the first page,
huddles in the urn of emotions ...

Sonia Balassanian (Published 1991)

I am looking at what Sonia has dubbed the "early" abstract paintings—works that she created devotedly throughout the 1970s. I first came across one of these non-concrete configurations on Salman Mantifar's iPhone, or was it in the pages of a poetry book at the home of Syrian-Armenian artist, Hrair Sarkissian? Salman had just returned to London from New York and I was invited for dinner, or so I thought. Before long, we were pulling apart newspaper clippings from *The Village Voice* when a cutting from 1978 that appeared in the now defunct *SoHo Weekly News* appeared. The article, entitled "Drawing Words," was devoted to poet and musician, Patti Smith, as well as to Balassanian's paintings. Detailing a series of canvasses presented at the Lotus Gallery, a gallery of which I could find no record today, the author, William Zimmer elucidates the texture and form of Balassanian's painted cubes, which are overlaid with her consciously concealed words. Here, the author equates her work with that of Cy Twombly (1928–2011), albeit without his "brute quality," he declares.[16] I examine his choice of words—his language ever so precise. Meanwhile, it is now past midnight in London, and Sonia is still on the Skype in her studio speaking to her gallerist, while

I photograph every single piece of ephemera that has been gathered. Zimmer's article ends by arguing that Sonia's work is both "sensual and surrealistic."[17] Absent, and perhaps most evident, is the contextualization of her paintings in the artistic genre of Lyrical Abstraction. This style first surfaced, it has been noted, in the mid to late 1940s in Paris, before taking root in the United States, where it gained its position in the canon of legitimacy.[18]

The artist's canvases from this period appear before me on screen. Many are still unstretched, as if still incomplete, and about to undergo a process of intervention or re-animation by the artist. A voice from the speaker queries whether we think these canvases

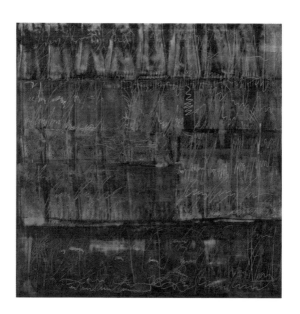

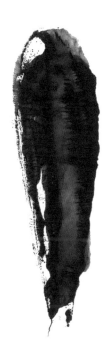

Untitled No. 49
from the *Brooding*
series, 1988
Monotype on paper
100 × 70 cm

Opposite:
Untitled, 1975
Acrylic on canvas
175 × 171.5 cm

should be stretched or remain as they are. The question is but a polite gesture, the answer is already determined, for the stretcher bars, wood, and staples have already been ordered. Scrutinizing Balassanian's work from the 1970s proves especially challenging. Despite the critical role of language within each composite picture, they are all "untitled," defined and described through each painting's divergent approach and gesture, in material and technique. *Untitled* (1976) presents concave arrangements, which repeat and dig into the canvas, forming a seemingly endless

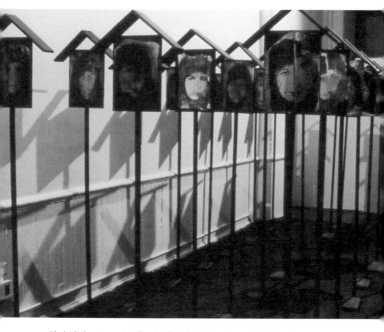

Black Black Days, 1982, collaged self portraits in custom-made metallic frames

grid. Here, the artist's attentiveness to various kinds of texture transpires—the illegible words camouflaging what she explains to be architectural forms, including, in this case, arabesques. Here, the result is evocative of the artistry of the Black American painter, Jack Whitten (1939–2018) and his trademark "paint as collage"[19] process. Invented in the 1980s, he mixed acrylic and powder pigments to create mosaic-like effects that led to three-dimensional surfaces, as seen in *Atopolis: For Édouard Glissant* (2014), which is held in the collection of the Museum of Modern Art, New York.

Throughout the years, Balassanian's abstractions would transmute into reformed rituals. She became concerned with masonry techniques—the circular, cylindrical, square, and angular, abstract stonework of local artisans that she saw in the countless monasteries she visited in Armenia. All the same, her abstract paintings can just as easily be situated alongside those of Thornton Willis, whose epic acrylic painting, *Red Wall* (1969), features repeated gestural lines that at once form a barricade, as much as they invite the viewer in to consider what is being disguised.

An undated painting by Balassanian from the same period is characterized by the childlike volatility of the artist's cursive formulae. Squares painted in the deepest ocean blue, are layered with blooming forms that resemble a sense of emancipation and of light budding into optical illusion. Here they are suggestive of Pat Lipsky's undulating waves, or Ed Kerns' mushrooming color fields, as well as Philip Guston's (1913–80) nonconcrete period of the early 1940s. Cubism and Surrealism appear to have lingered in the artist's subconscious, but one can also draw parallels with the majestic kaleidoscopic paintings of Fahrelnissa Zeid (1901–91), a Turkish-Jordanian painter who was one of the first women to attend art school in Istanbul. A prime example can be seen in Zeid's seventeen-foot-wide painting, *My Hell* (1951), whose tessellating, geometric forms evoked the artist's interior state of mind. Painting circumstantially within the context of both these women's lives becomes a site to purge personal trauma, and to imagine the possibilities that exist beyond it.[20]

Many of Balassanian's paintings from the 1970s, much like the linguistic forms that they obscure, are polyglot. The visual language

of each composition is as much in the tradition of American painting, as it is inflected and fashioned around her Armenian poetry. In this regard, she is neatly situated within an archipelago of thought rituals—Glissant's most famous of metaphorical propositions. In this location, the act of creolization engenders the possibility for a new linguistics to form, within the multiple diasporas in which we collide.[21]

Keep looking, until the secrets reveal themselves.
Keep looking, until the landscapes in the background brim to the surface.
Keep looking, until the tide changes; everything that existed, all that you believed in, fleetingly dissipates, into nothing: a once over.

Installation view, artist's studio, 1982, New York

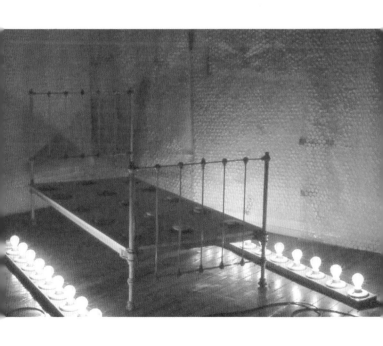

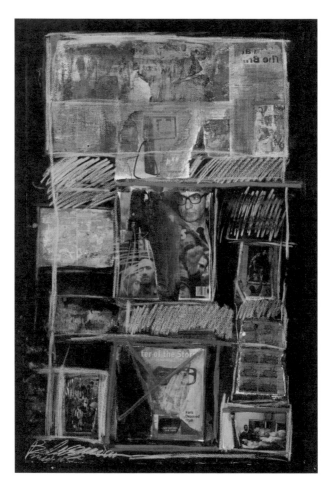

Above and following pages: *Hostages: A Diary*, 1980, images from a unique installation series of 41 works, collage, acrylic and mixed media on paper, dimensions variable

The Political Tides are Changing

The seconds expire
Time doesn't stop to rest
 It runs breathlessly ...
My face is burning from fire
My body melts
Time runs breathlessly ...
My face is aflame

Sonia Balassanian (Published 1991)

FADE IN:

The hostage is a friend.
The hostage *was* a friend.
Let me remind you that *those* hostages were not
just *someone's* friend or family.
They were *her* and *my* friends and family members.

Before the collapse,
Monir Shahroudy Farmanfarmaian (1922-2019),
who would in her final years become Iran's most
celebrated of female artists, calls Sonia,
before she escapes herself.
"Grab your son and go."
Only having returned to Iran from nearly a
decade in the United States, Sonia must have
pondered: was *this* revolutionary impulse, as
calamitous as the grumbling that was cautioned?

For the scene outside the window, was
disaffectedly calm.
Having come face-to-face with perceived
"revolution"—
Having survived reported acts of "terrorism" as
confirmed to me by global news media—
I admit that there is a certain tranquility that
pervades air and conscience:
Before *the* initial blast, *the* eruption, occurs.
What ensues:
is no rave.
no ball.

Edward, Sonia's husband, by this point, a noted
architect, could not for practical reasons,
depart from his position as a city-planner.

When Sonia arrived in New York this time around—
Newfound melancholy consumed her at first.
Her coping mechanism was not intuitively fueled
by artmaking—
Not that she was aware of, anyway.

An activist was born.
But her vested commitment would soon lead to new
winding paths.
Vectors into concerns and media that birthed a
new artist.

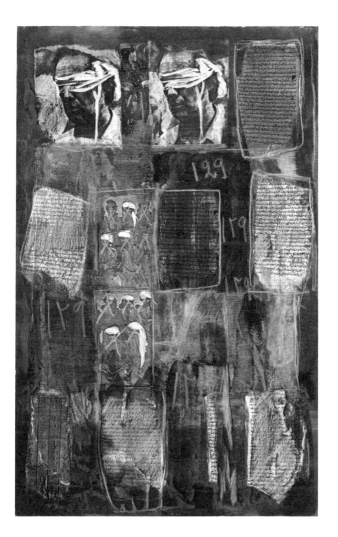

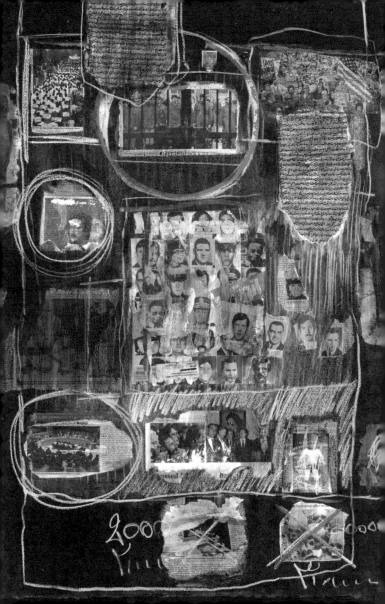

Hostages: A Diary is dated as having been produced in 1980. The setting for this artwork is a now infamous act, popularly acknowledged in political history. In November 1979, when the former Shah of Iran was in the United States seeking cancer treatment, a group of militarized, college age students, in support of the recent Iranian Revolution, were reported to have been incited to take seizure of staff on the grounds of the US embassy in Tehran. They initially detained sixty-six American citizens, and ultimately held fifty-two hostages for what, at the time, seemed like one of the most protracted, and visibly narrated political events carried out against the United States—they were held for 444 days. In mainstream media, the event was dubbed the "Iran hostage crisis," although in retrospect, the word "crisis" perhaps insinuates the perception of the US media of American security forces' failure to gain control over these radicals-turned-captors. It seemed both unfathomable and imprudent for the captors to carry out such actions against the nation that had decimated Hiroshima and Nagasaki in 1945 and caused mass fatalities in the twenty-year Vietnam War, which had only ended in 1975.

A crisis is also a turning point, and for Sonia Balasannian, it was a moment to take inventory. Reportedly, the forty-one mixed-media collages that form this transitional body of work began with her cutting out clippings from the newspaper while watching the evening and special news broadcasts. "I thought that I would make an archive for my husband for when he would [eventually] come home to New York to see what I knew he would not see in Iran."[22] Amidst what became a dutiful process of cutting and affixing these clippings to the large walls of their loft, certain patterns began

to emerge. The artist would notice certain key aesthetic tendencies, individuals, and motifs—figures who became conduits through which the audience could experience the familiar so as to engage empathically. One figure, loops, repeats and forms a constellation. He is almost Christ-like. A deity.

Closer inspection of this picture, which can be found on the cover of the exhibition brochure accompanying the presentation at Elise Meyer Gallery, when the hostage crisis was only halfway through. The image reveals the central figure in this duplicating image as a proposal of a specific visual binary. Slightly behind the blindfolded American diplomat is the face of his captor—a young Iranian man. His face caught gazing straight at the camera, lips slightly parted, as if gobsmacked at the prospect of being watched. The white, middle-aged man, in contrast, has lips pursed, his face angled slightly away from the camera, his blindfold perhaps loosening. Initially, upon examining these forty-one collages, I assumed him to be the "face of the crisis." However, I could not find this person's likeness in any of my research on the Iranian Revolution. When my eyes finally shifted from the victim to the perpetrator, it became evident that the image was the same one, repurposed by the artist. In many instances, the captor's image was bleached, dyed, painted, or scratched out. The looping echoed the news media itself. This point is re-affirmed in the short introduction to the brochure by the academic, Robert C. Hobbs, who referred to the series as "Icons of Crisis." The tone of his text treads cautiously on a fraught matter yet makes evident two key points. The first is that Iran's revolution, unlike others, was perceived adversely in the western world due to the explicit rejection of "Western modernization efforts"; and laterally, Hobbs ends, by conceding that the western purview of what is or was ever progressive now constituted "an antiquated modernism."[23]

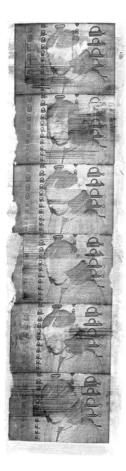
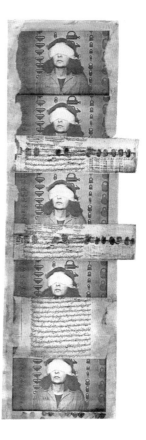

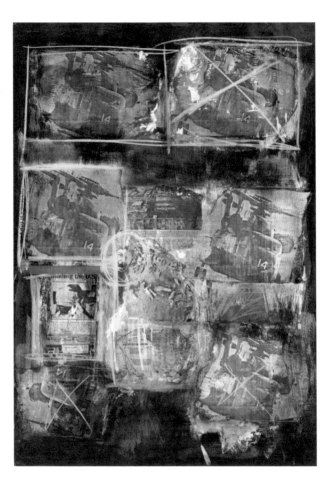

The lexicon of 1980, in New York, was becoming attuned to postmodernity, with its tendency for self-reflexivity demanded of the critic, and by proxy, the artist. Yet what I see amidst Balasannian's diary are two striking visual points of reference that exist at divergent poles of the cultural spectrum. Certainly, one can argue that collage and appropriation were, at the time, brought fully into mainstream artistic fields such as Neo-Dada, as emblematized by Rauschenberg, who delineated the interplay of the quotidian, the iconoclastic symbolism of mainstream media, and the practice of appropriation.[24] The majority of the collages within *Hostages: A Diary* are presented as three topographical planes—as long strips of intertwining figures, such as the Supreme Leader of Iran, Ayatollah Khomeini, celebrating his birthday, or repeated representations of women seemingly doused in a chador, the black full-body veil and shawl. A central figure is often accompanied by two others who are less visible. The materials are fragile, like the parchment of medieval manuscripts, such as those by artist Taddeo Crivelli (1451–79), a fifteenth-century Italian illuminator. A prime example is his work, *The Trinity* (c.1460–70), now in the collection of the Getty Museum, Los Angeles. Its representation of the Holy Trinity—God the Father, Son, and Holy Spirit—as a central tenet of Christianity, and the visual symbolism and iconography that accompanies it, expresses a desire for unity of spirit and form—three persons in one Godhead. Albrecht Dürer's (1471–1528) Renaissance altarpiece, *Adoration of the Holy Trinity* (1511), now in the Kunsthistorisches Museum, Vienna, is equally noteworthy here.

The compositions within Balasannian's diaries are inherently Biblical—iterating deity-like subjects. The work draws on the artist's Armenian background. Her native country is today

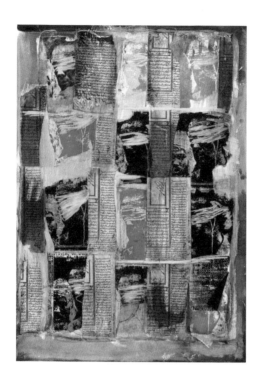

recognized especially for its historic monasteries and churches—
Khor Virap (Deep Dungeon) monastery, Zvartnots Cathedral,
Marmashen monastery, Katoghike church, and Geghard monastery,
which are all renowned for their detailed engravings, stone carvings,
and scenic settings—sites and subjects that would emerge in the
artist's practice explicitly in the 1990s. One can argue that they
also influenced Balassanian's particular attention to texture—the
scratching and coloring of cutouts from magazines and newspapers.

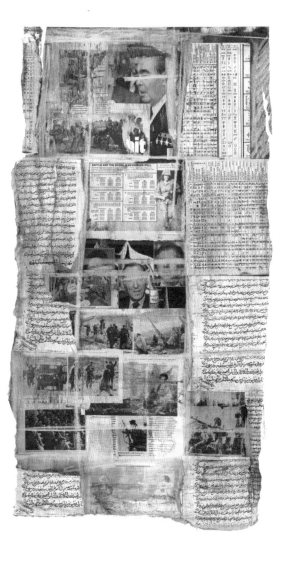

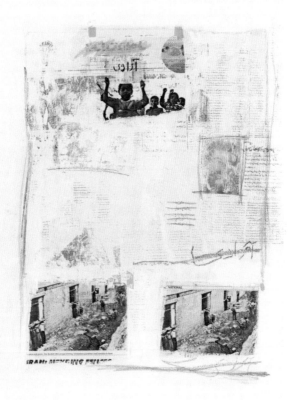

This approach can be attributed to a tradition of revealing and concealing palimpsests—ones that emerge from geographical contexts of war, where official archives or records may not exist.

The photographic realism in *Hostages* is posited against mystical suggestion—spirits and saints. Thwarting a linear reading is the artist's insertion of her own person. An interspersed woman, Sonia, at times veiled and unveiled, can be seen blindfolded. The artist is acknowledging the subjective impossibility of a witness bearing sight of historical trauma from a distance. Outside of the artist's presence, there seem few, if any, visible women at all. Iran, during the time of what was also called the "Islamic Revolt," would over time introduce policies and cultural stigmas that required women be entirely covered up, concealed, visible, but always hidden from view.[25] Consider these pictures through the theoretical lens of obfuscation, and what you might see are a series of male figures, free form, who almost start to resemble caricatures of themselves. The aesthetic of hyper-appropriation begins to resemble meme culture, popularized decades later in the age of the internet. A meme is a behavior or idea that spreads, often online through the experience of imitation, most often demonstrable through short videos and images published and shared via social media.[26] The embodied gestures, poses, and expressions of these figures, looked at collectively today, may well be suggestive of such cultures. *Hostages: A Diary* is consequently an archive of expressions—an index of human features as they first appeared, at a historical juncture when news engines were fewer; when public reflection was less visible. And in that womb of enclosure, there may have just existed, a form of invitation for experimentation that does not exist anymore.

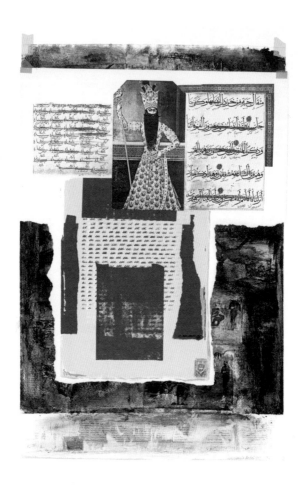

Take me to the Other Side!

People say lyrics have less literary merit than poetry
They say photography is the lesser of the fine arts … and we're done—[27]

CUT TO:

Another living room scene.
Another WhatsApp call—
International news plays in the background.

A harrowing tale is articulated to me, a
personal story, a friend, a woman—
Raped with a paper bag on her head,
Sonia describes the sound of the women's breath
as she narrated the story.
I imagine that her hands are trembling, now.
The conversation ensues into a discussion of a
painting of Khomeini—an image that none of us
will ever see.

I received a picture message from Salman
Matinfar.
A self-portrait of the artist in black, donning
a chador, situated in a dark, cavernous wall,
or is it a painted antechamber?
I am informed that this image came from her
home.
The beginning of something has begun.

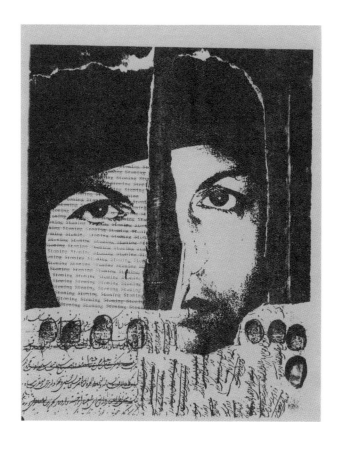

Self Portraits, 1982, from a series of 18 self portraits, mixed media collage on paper

We are discussing a series of eighteen self portraits that were made for an exhibition in early 1982, which was presented as part of a major exhibition at the Museum of Modern Art, New York, in 1988 called, "Committed to Print." These pictures, which seem as if they were purposefully torn, splintered, burnt, almost ashen, expose twelve distinctive gazes to the viewer. Each is accompanied by typewritten text, in English, of a different violent act committed against a woman in Iran, including "raping" and "stoning." These words are repeated, often redacted. In certain compositions, the words are presented exclusively in Farsi, scrolled over the subject's multiplied faces. As I peer closer, it appears as if the pictures themselves were the subject of an "acid attack," bringing to mind a spate of violent acts reported in the international media, that occurred in Isfahan, Iran, in 2014.[28] The faces appear as reconstitutions, a singular person's visage, stitched together, that become redolent of the multiplicity of a single person, as much as they are animated experiments in self-contortion.

I am reminded of Joana Hadjithomas and Khalil Joreige's body of work *Wonder Beirut* (1998–2006), postcards as self portraits, reconstituting a memory of Lebanon and Beirut before the Civil War (1975–90), and an aspiration for the potential future. More acute is the presence of Adrian Piper, whose acts of self-portraiture throughout her career have explored the visual pleasures constituted through various acts of looking. Her numerous forms of embodiment in works such as *The Mythic Being* (1974), through to *Self-Portrait of a Nice White Lady* (1995), are communicative of a form of code-switching noted to have been required of Black Americans, and people of color

more broadly, to survive.[29] "Passing" becomes a mechanism for accession, or in Piper's case, for gazing back at the practice of white male-dominated scopophilia—decoding the pleasures gained when an object or person performs in a specific manner.[30] Balasannian's self portraits begin a process of interior reconstitution—a negotiation with herself of the many selves that she may now have to embody on the one hand, as a Christian Armenian in the diaspora, an Iranian within the diaspora, but more centrally, she argues when we speak, is a desire to embody the dispossessed who are not afforded the right to speak. I prod gently.

Sonia Balassanian: "These self portraits emerge from my poetry, don't you think?"
Pause
Author: "But it is not poetry, but it is …"
Sonia Balassanian: "I believe that they are filling voids … erasure … rupture."

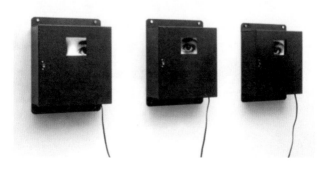

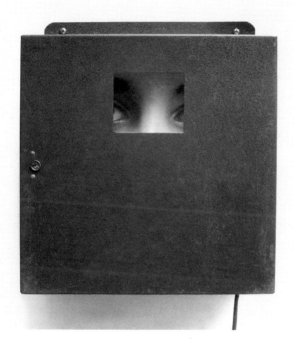

The Other Side, 1991–92, close-up of lightbox, 15 × 12 × 15 cm

Opposite: *The Other Side*, 1991–92, installation of nine lightboxes, installation view:
Sculpture Centre, New York, 1992

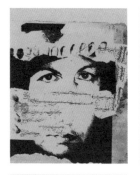 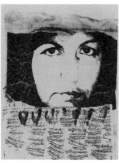

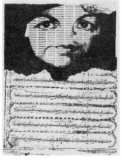 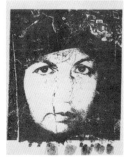

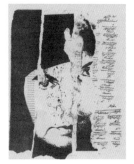 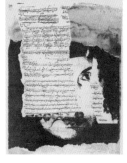

The redaction of the media, but which one? As world politics are renegotiated, the interplay of forces in the global order is expressive of bifurcation—different "evils" align together to form walls of geopolitical and socio-economic power. That supremacy, or dominance, as Balassanian, is ever so aware, is also ideological. If, as Susan Sontag (1933–2004) once argued, "art is not consciousness" but rather "its antidote," there is one specific intimation that emerges: that the serious artist deploys the inner dwelling of the mind in the purest form through the "silence" of art-making, preparing for "the right to speak."[31]

The question, or rather, the conundrum of "who has the right to speak" has shifted from a binary dialectic that ripened in the public arena after the omnipresence of Edward W. Said's (1935–2003) *Orientalism* in 1978, and with the proliferation of postcolonial theory in the cultural milieu in the late 1980s. Today, the right is a matter of collective debate, with the ebbs and flows generated by the proliferation of a more immediate, interactive, and visual media culture.[32] Balassanian was crisply in focus during the rise of art and postcolonialism. This was demonstrated in two successive career moments: a solo presentation at the Sculpture Center in New York (before it became stylized as SculptureCenter), entitled, "The Other Side" (1992); and a significant presentation in the Museum of Modern Art's "Readymade Identities" (1993), a group exhibition that explored clothing's influence on culture and society through the work of six artists, which also included Ann Hamilton and Fred Wilson. Both exhibitions featured the installation, *The Other Side* (1992). Here, mannequins stand

Self Portraits, 1982, from a series of eighteen self portraits, mixed media collage on paper

clustered together in an "over-exaggerated" personification of the chador.[33] Behind these veiled figures, spotlights shine, making visible their physical state—suspended somewhere between the surreal, the make-believe, and poignant sentiment. Balassanian's name circulated widely within the press during the exhibition at MoMA, forming significant debate. This was a cultural moment before the critical examination of the Islamic cultural rites and rights had come under scrutiny in the public domain. Sonia Balassanian, despite being a Christian, precipitously became referred to as a voice for oppressed Muslim women—the evolution of this work continuing in *The Other Side 2* (1993), a subtler exploration of backlit eyes that peer out of metallic boxes. Expectedly, the artist's visual lexicon was now associated with the kneeling postures of these veiled sculptures, also seen in *Shadow of My Sisters*, which followed the same year.

Jeff Fleming, then curator at the Southeastern Center for Contemporary Art in North Carolina, introducing *Shadow of My Sisters*, at the time wrote that the artist's work was an exercise in examining the "victims of persecution and intolerance worldwide."[34] One could propose that these installations, sculptural and embodied, may have influenced myriad later artworks that explore the acts of redaction and revelation associated with the veil, including those by artists such as Jananne Al-Ani, Kader Attia, Emily Jacir, Shirin Neshat, and Harold Offeh.[35] Another analysis of these lumpen, drooping bodies could relate back to Balassanian's spectrum of influences—from John Cage (1912–22) to her diligent attendance of theater and her attentiveness to experiments in play and making. One could invoke Cage's most recognized work, *4'33"* (four minutes, thirty-three seconds), which, in its initial incarnation from 1952, specified that the

musicians were to appear onstage but do nothing. They were to remain in silence, for the duration of the score. The result is a "performance" generated by the tiniest movements and interstitial anxieties of the audience. In Balassanian's *Shadow for My Sisters*, one can imagine that these unusually positioned bodies in chador are "playing out" the absurdity of their context as tricksters who are literally undercover.[36]

Shadow of My Sisters, 1993, fabric, lights, paper, plaster, wire, and wood, eleven figures, each 183 × 92 × 61 cm. Installation view: Southeastern Center for Contemporary Art, Winston-Salem, North Carolina, 1993. Photograph: Jackson Smith.

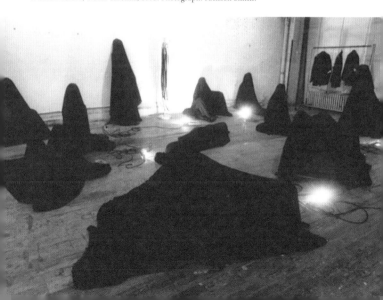

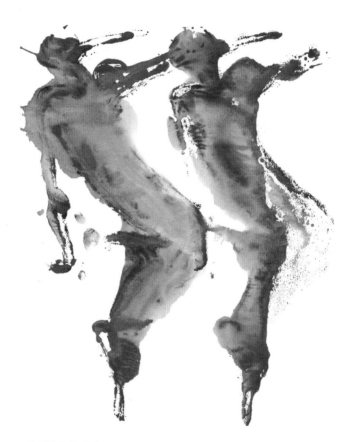

Untitled No. 32, 1988, monotype on paper

Sense and Sensuality

Feet sink in earth.
Ties spurring light of eyes
To missiles hanging from the planets ...
Soaks his hands in the stardust ...
Hurl it at the sun
and darts towards infinity
An earthen-lipped child

Sonia Balassanian (Published 1991)

Almost everything we do, we do for effect. But the intention or meaning of that may not emerge for decades after the initial act of making.

I am enraptured by a work on paper from Balassanian's *Brooding* series of 1988. In the first picture I encounter, two transmuting bodies cast in orange ink appear to hover, suspended in air. Their silhouette suggests something between animal and human. The duo jut, bump, and seemingly hump—literally swelling into each other, digesting each other's forms. I interpreted this as a sensuous and queer undertaking. The monotype technique—now a rarely-used form of printmaking in which unique prints are gleaned from a design created in ink or oil—allowed the artist to create a series of interlocking forms, where the thickness of the toner would coagulate in certain sections and trail off in others, diluting the possibility of a singular construal.

These pictures, more intimate in scale than her paintings and collages, were purposefully conceived to evade categorization, Sonia informs me. On occasion, the male forms oscillate towards the intersex and transexual, as the colors intensify in darkness. Exhibited in 2004 at the Armenian Center for Contemporary Experimental Art, Yerevan, a catalogue with an essay by the American poet and art historian Donald Kuspit likens these figures to "Egyptian deities," drawing parallels with these images and Anselm Kiefer's "smoldering ruin."[37] Kuspit, who is known for his astute, psychoanalytic approach to criticism seems to miss a trick when he notes that the work, unlike most "post postmodern art," is non-ironic.

Film stills from *Chain*, 1995, single-channel video installation

Imagining Otherwise

Every person, it is assumed, has their root and route. Yet, origin myths are commonly linked to a sense of anachronism, fallacy, and make-believe. In early adulthood, I was consumed by the writing of female authors, with a particular affection for Marguerite Duras (1914–96) and Zora Neale Hurston (1891–1960). I became fixated on the plumes of smoke seen in the pictures of them, and perceived the cigarette as the agent of creative wholeness. The chronic bronchitis that ensues as I cough my way through any given manuscript has done much to dispel the perception that chain-smoking activates the artistic impulses, or that it improves one's penchant for storytelling. The artlessness of my own lived experience represents an adolescent form of searching—for (my)self, but more pivotally, for a notion of community—an opportunity to be singular with others, with individuals who I perceive to be akin to me.

The impetus behind this book series is the consequence of personal experience. In childhood, I was situated amidst multiple cultural poles, all of which committed me to being a royal disappointment. My teenage years were lived in a country where no visual culture existed—censored, banned, cut up, blacked out, and redacted from view. It was then that the concept of queer erasure emerged as a concept to me.

Jingoism dovetailed with xenophobia as I came to maturity in the aftermath of the terrorist attacks of 9/11—bearing a name that was frequently assumed to be Muslim. Being queer, non-binary, and disabled, among other things, did not divert the attention away from

this fact, especially during my time living in the United States. Since I began working professionally as an author and curator over seventeen years ago, the rhetoric of societal polarization has pervaded public consciousness, marked by different intensities. In my experience, the realm of culture—whether for-profit or not—was a corporate sphere, often ageist, ableist, elitist, and intolerant of difference in relation to artistry or artist's identity, unless it was to instrumentalize this for economic gain. I have been informed by certain peers that I am fortunate to have been able to guide patron groups around exhibitions that I conceived and curated, to dine with collectors, and to meet with philanthropists and book publishing executives. But on many occasions, I have found myself a performing phantasm: interrogated, pressured, and prodded into being the subaltern subject—someone who wasn't from here, or there, or anywhere that the folks elbowing me, could ever know.

Although a student of postcolonial theory and its effects, I eventually resolved to exit the echo chamber of binary opposition. In 2012, I founded a platform (reborn and renamed in 2022), artPost21, which is fashioned to nourish artistic collaborations that exist strictly outside the fold of opposition. Rather, each artistic pursuit is an effort to signpost a path towards new expressions of culture. Sonia Balassanian's book, the first in the anthology *Imagine Otherwise*, marks the project's first significant publishing collaboration with Sternberg Press.

Imagine Otherwise emerged from and through a confluence of challenges, which find release in this form. Each volume sets the reader forth into the realm of a queer, non-binary, female artist, or collective's work, who, at the time of commissioning, do not have a book about them in print. The resources offered to each book,

despite the intentional pocket-sized and distributable form, is immense. Individual projects are assembled out of sparse archives, from ruins, or, in some cases, sites where no archive exists. The process of constructing this topography accordingly necessitates a distinguishing tool kit to enable space for these stories to come to life, enter the world, and develop their agency.

To guide this process, a rotating, advisory board has been formed who will help steer the editorial process into landscapes new. This group of people also exist to nurture the development of an ever-evolving set of indexical tools, which allow for the finessing of style, language, vocabulary, and grammar. Stylistically, this anthology operates from within the bounds of Saidiya V. Hartman's concept of "critical fabulation"—put in simplest terms, a mechanism and aid in the study of suppressed histories, whereby conscious uses of fiction are deployed to animate, develop, and give life to subjects who otherwise may remain unseen or unknowable.[1] Within this paradigm, the authors in this series will construct biographies that demonstrate a knowing intimacy—intermingling personal affection with critical analysis of an artist's work and life.

To liberate authors from the oppressive tendencies of historical prejudice, each writer is invited to let go of geographic hegemony. For the sake of levelling out, the series begins without the capitalization of east and west, north, or south, and, to avoid any potential ageism, living artists and other individuals mentioned, do not have their dates of birth cited, unless with their consent. This may be subject to change, for if language is the primary technology of expression, the thirst to evolve its contours, must be matched by and with the informed knowledge of those that it seeks to define, to also be able to define it themselves.

Over the course of the last two decades, I have written and talked about many subjects that I have found difficult to express as the "self" I am perceived to be. When I entered the academic worlds of museums and universities, it felt essential to avoid vulnerability and *noms de plumes* appeared from within me. From them, characters were forged, to engage with topics of gender expression, sexuality, and ethnicity, in a manner that I—as myself—feared. Over time, these characters began to develop their own sets of mythology and expression. In 2019, I wanted to reclaim something of them, so *something must have changed* for the better. I brought forward a voice that had not spoken as this author before.

These words were spoken in public on March 11, 2019, later to be excerpted in an anthology, *Creating Dangerously*.[2]

> B-lending/Two faces, just discernible/Corpulent or barely stout/the Afro-Bar-Barbarian/The Muslim pentagonite/ Body bits that require more than two hands to hold …/" [and so I leave you with] "Two obsolete forms:/binary genders, hollowed rituals/un-sutured pieces of coil/ Together 'they' of 'brown skin' and *they* of 'fair eyes' are permitted to an amalgam. /Two fragments, unabridged … .

With this fervor, it is an ambition to develop a socially just and inclusive form of archival practice—one based on the fabulations of the vanquished. A constellation of texts and images that narrate the art and lives of the gendered, and for those for whom gender exists somewhere in the middle of nowhere. To cultivate the space for all those who cannot do with ticking any box. Here, the aim is to offer refreshed indices of history, at whatever scale that this given moment affords us. Together, we can work in search of a

vocabulary that is focused, as opposed to common to no one. With this first book, I invite you to think beyond the extraction of the "other" in favor of the sensorial pleasures that emerge when we, *imagine otherwise*. [3]

1. Saidiya Hartman, "Venus in Two Acts," *Small Axe* 12, no. 2 (June 2008): 1–14.

2. Omar Kholeif and Blake Karim Mitchell, *Creating Dangerously* (London: SAF, 2019/2021), 198–99.

3. Although this series, and its title, were conceived during the writing of my doctoral thesis, which was completed and defended in 2015, it nonetheless, feels important to mention British Black feminist author, Lola Olufemi's lyrical book, *Experiments in Imagining Otherwise* (London: Hajar Press, 2021). Indeed, as its title suggests, any opportunity to distinguish forms of thought, must first be explored through acts of experimentation.

Acknowledgements

On the back cover of the black-and-white publication for *The Thin Black Line*, an exhibition of Black women artists curated by Lubaina Himid in 1985 at the ICA, London, the following words are spelled out in capital letters, "A SUBLIME ACT OF CULTURAL TERRORISM." I would like to think that all my acts operate from a similar logic and it is indeed, within the tenacious spirit that Himid fashioned *The Thin Black Line*, that most of my nourishing work has come to bear—taking advantage of being in the interstices and flipping that around. Accordingly, I must begin by thanking Lubaina Himid, not only for serving as a constant site of inspiration, but also, for her structural support, which has helped get **aP21** back off the ground— initiating projects, such as this one. Thank you, and evermore. To Magda Stawarska-Beavan, thank you for being a constant champion, a sensitive listener, and a consistently affecting artist, *merci*.

This series would not exist without the unwavering belief of Caroline Schneider of Sternberg Press—partner, and collaborator, to whom I am deeply grateful. Azadeh Zaferani and Salman Matinfar, co-founders of Ab-Anbar, have been generous companions. It was a privilege to work with you—your steer through the extensive primary research materials were fundamental to shaping this publication. Rebecca Morrill, I cherish the opportunities to be guided by your kind, curious, and thought-provoking editorial hand. Simon Josebury, your patient, sensitive, and affecting treatment of Balassanian's art, and my words, were magnificent. I am proud to say that the series is designed by SecMoCo.

To Sonia Balassanian, thank you for inviting me into your world. I know it is still but a mere slice of it all; I look forward to weaving my way through the unsewn edges, and archives, ever. And to Arné and Edward Balassanian, for your generosity in filling in the gaps, where and when necessary.

Frank Gallacher, Sofia Victorino, and Hrair Sarkissian, thank you for your gentle interventions, your steer, and encouragement throughout this surreal time.

Artist and Author Biographies

Sonia Balassanian was born in 1942 in Iran to parents of Armenian origin. She lives and work in New York and Armenia. Balassanian's career spans more than five decades, working across multiple disciplines and media. Her life as an artist began as a teenager in Iran, authoring poetry. Following her move to the US, her work took on new meaning. Balassanian graduated with a BFA from the joint program of the Pennsylvania Academy of Fine Arts and the University of Pennsylvania, Philadelphia, in 1970, followed by a year at the Whitney Museum Independent Study Program, New York. She graduated with an MFA from the Pratt Institute, Brooklyn, in 1978. Sonia Balassanian's painting emerged as a form of Lyrical Abstraction before it took a dramatic turn after the political turmoil that led to the Iranian Revolution of 1979. Her art became more explicitly political, and the artist in turn, also simultaneously operated as a social activist for women's rights. Her work has been featured in exhibitions at MoMA, New York; SculptureCenter, New York; Musée d'Art Moderne de la Ville de Paris, and the Armenian Pavilion at the Venice Biennale.

Dr. Omar Kholeif aka Dr. O is an author of prose and poetry, a historian of the academy and its peripheries, and a curator of vanquished and/or suppressed archives. They have worked as a broadcaster, filmmaker, editor, publisher, and museum director in South Africa, Britain, United States, the GCC, and in Northern Africa. Over the last seventeen years, their work has concentrated on the evolving nature of networked image culture in relation to the intersectional questions emerging in the field and study of ethnicity, race, gender, and sexuality. The curator of over sixty exhibitions, and over thirty authored, co-authored, and edited books, their work has been translated into twelve languages. Dr. Kholeif was co-curator of *Sharjah Biennial 14: Leaving the Echo Chamber*, and serves as Director of Collections and Senior Curator, Sharjah Art Foundation, UAE. Kholeif is founding director of www.artpost21.com. Their monograph, *Internet_Art: From the Birth of the Web to the Rise of NFTs* will be published by Phaidon in 2023.

Colophon

Omar Kholeif
Imagine Otherwise
Vol. 1: Sonia Balassanian

Editor: Rebecca Morrill

Translation Support:
Sonia Balassanian with
Arné Balassanian and
Edward Balassanian

Proofreading: Stuart Bertolotti-Bailey

Design: Simon Josebury, SecMoCo

Printing: Aldgate Press, London

ISBN 978-1-915609-07-6

Published by

SternbergPress

Sternberg Press
71-75 Shelton Street
UK-London WC2H 9JQ
www.sternberg-press.com

An artPost21 Production
www.artpost21.com

Distributed by The MIT Press,
Art Data, Les presses du réel,
and Idea Books.

All images courtesy the artists and
Ab-Anbar, unless otherwise stated.

Every effort has been made to
contact the rightful owners with
regards to copyrights and
permissions. We apologize for any
inadvertent errors or omissions.

in partnership with

www.ab-anbar.com

Cover image:
Untitled, 1981
Acrylic and mixed media
on canvas
183 × 183 cm

Image page 1:
Untitled (n.d.)
Oil and mixed media on
canvas
190 × 181.5 cm